Hebridean Birthday Book Illustrations by Mairi Hedderwick

First published in 2006 by Birlinn Limited West Newington House 10 Newington Road Edinburgh EH9 10S

www.birlinn.co.uk

Reprinted 2010, 2014, 2018

Copyright © Mairi Hedderwick 2006

All rights reserved. No part of this publication may be reproduced, stored or transmitted in any form, or by any means, electronic, mechanical or photocopying, recording or otherwise, without the express written permission of the publisher.

ISBN: 978 1 78027 538 3

British Library Cataloguing-in-Publication Data

A Catalogue record for this book is available from the British Library

Printed and bound by PNB Print, Latvia

These Hebridean sketches have been garnered over a period of forty years – some whilst living on one of the islands, others as I escaped from mainland

exile. Some landmarks are no more – a post box disappeared, the old pier superseded by the new, many hens long gone into the pot. The mountains and headlands and the horizon line of the sea, however, never change – or diminish. And neither do the midges.

The Clyde island of Arran is not truly Hebridean, but as one set of my forebears hailed from Corrie, I am sure that they would have been pleased with its inclusion; as I hope you are with this Hebridean Birthday Book.

- Maixi Heddeningk

1 January

2 January

3 January

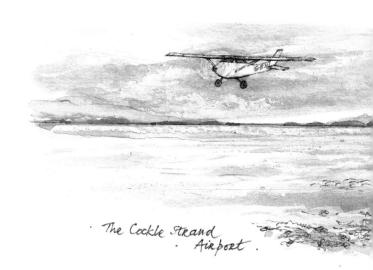

4 January 5 January 6 January 7 January

8 January		
9 January		
10 January		
11 January		
12 January		, <
13 January		 24
14 January		

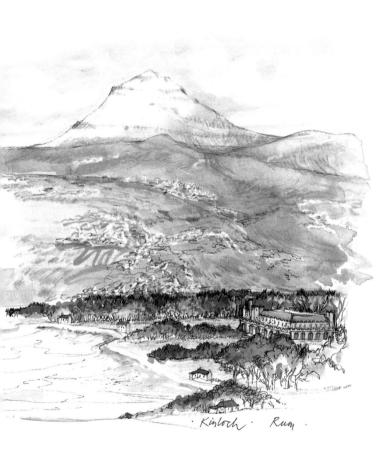

15 January		
16 January		
17 January		
18 January		
19 January		
20 January		
21 January	 ***************************************	

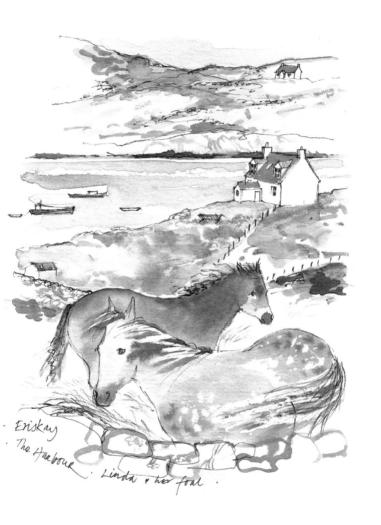

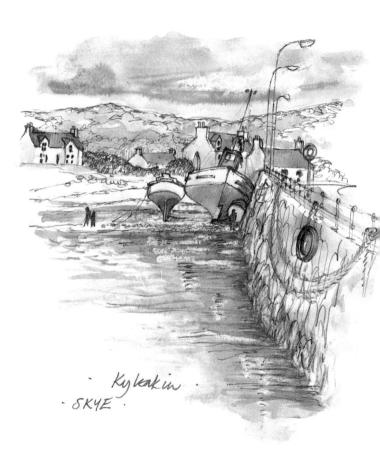

22 January			
23 January			
24 January			
25 January			
26 January			
27 January		ž	
28 January			

29 January

30 January

31 January

1 February

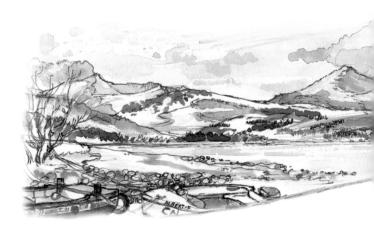

2 February

3 February

4 February

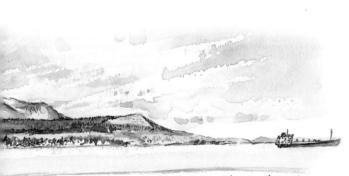

· Goarfell · Brodik · ARRAN

5	February	
6	February	
7	February	
8	February	
9	February	- The state of the
10	February	
11	February	

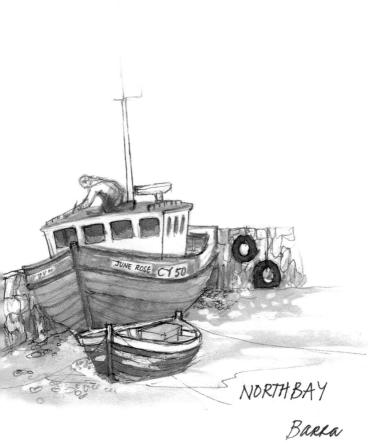

12 February
13 February
14 February
15 February
16 February
17 February
18 February

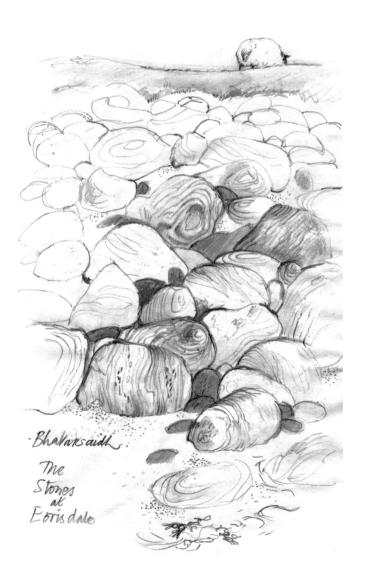

19 February	
20 February	
21 February	
22 February	
 23 February	

24 February

25 February

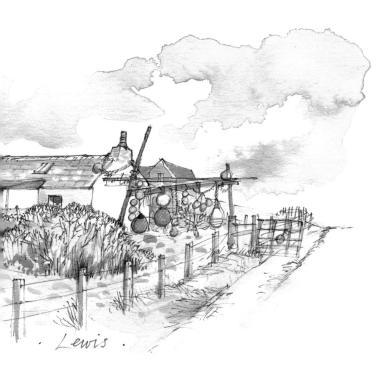

26	February
27	February
28	February
29	February
1	March
2	March
3	March

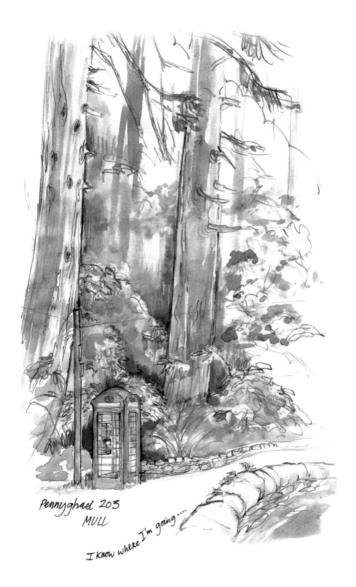

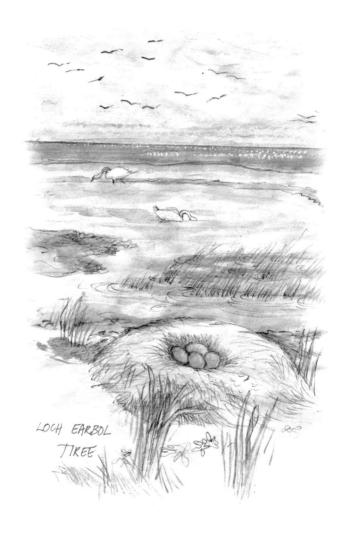

March					
March					
March					
March					
March					
March					
) March					
	March March March March March	March March March March	March March March March March	March March March March March	March March March March March

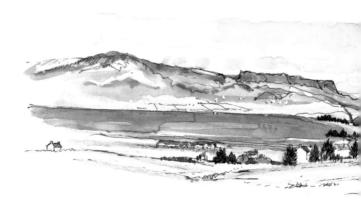

12 March

13 March

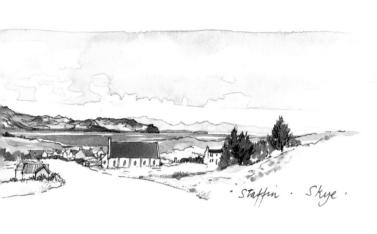

16 March

18 March			
19 March			***************************************
20 March			
21 March			
22 March			
23 March			
24 March			

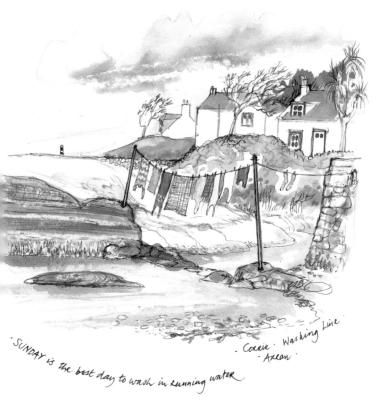

26 March

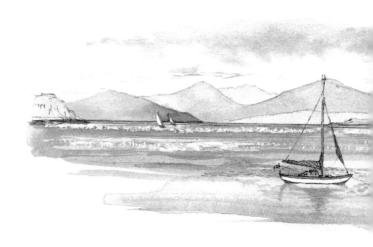

29 March

30 March

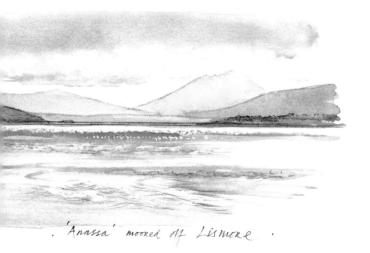

1	April			
2	April			
3	April			
4	April			
5	April			
6	April	-		
7	April			

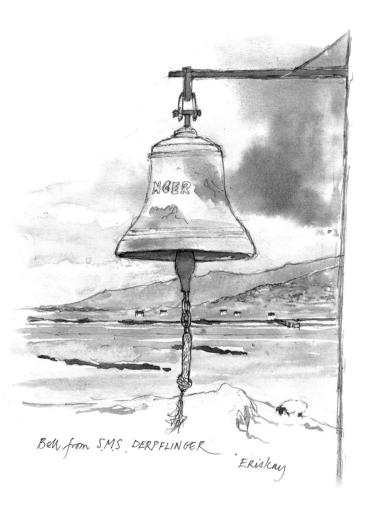

8	April	-	
9	April		
10	April	 	
	7 10		
1	April		
12	2 April		
13	3 April		
12	4 April		

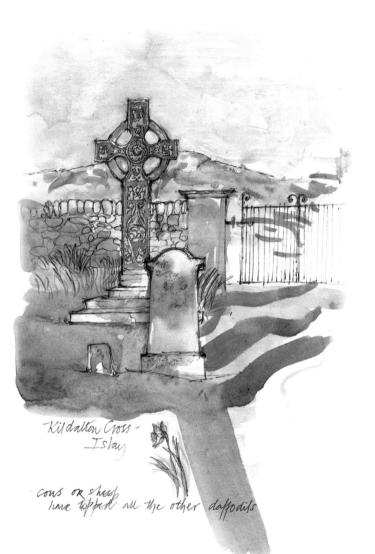

15 April

16 April

17 April

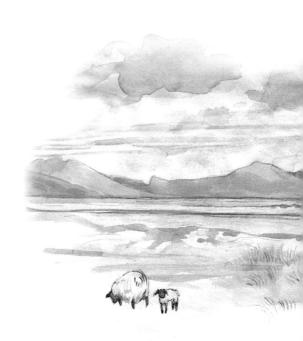

18 April

19 April

20 April

21 April

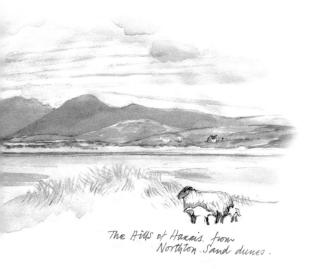

22 April				
		,	 	
23 April				
24 April	,			
25 April				
26 April				
27 April				
28 April				

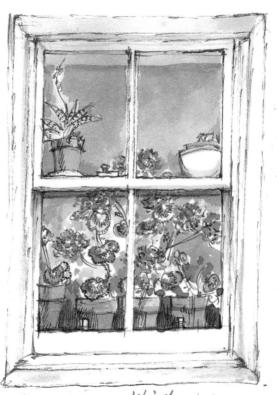

. Window . IONA.

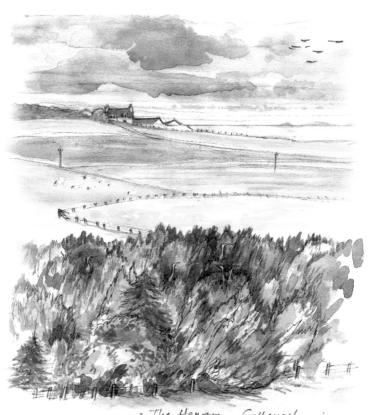

- The Heroury - Gallanach . Con .

29	April			
30) April		 	
1	May	 		
2	May			
3	May		 	
4	May	 		
5	May	 		

7 May

8 May

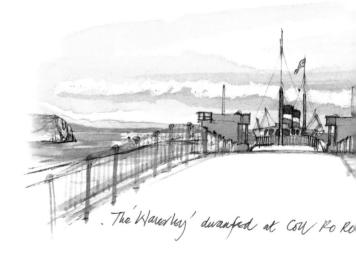

11 May

14 May

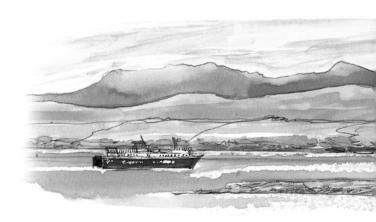

17 May

18 May

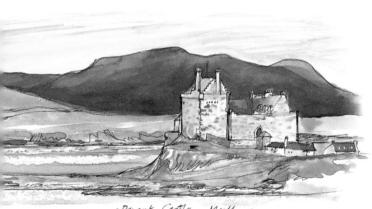

- Puant Castle. Mull

20 May			

22 May			
23 May			
24 May			
25 May			
26 May	 	 	

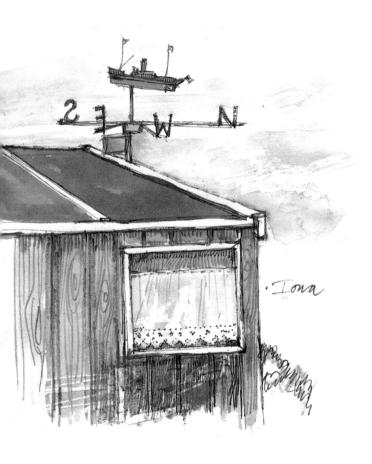

27 May

28 May

29 May

30 May

1 June

2 June

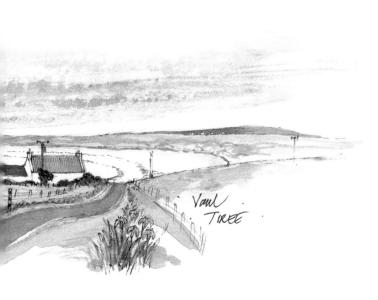

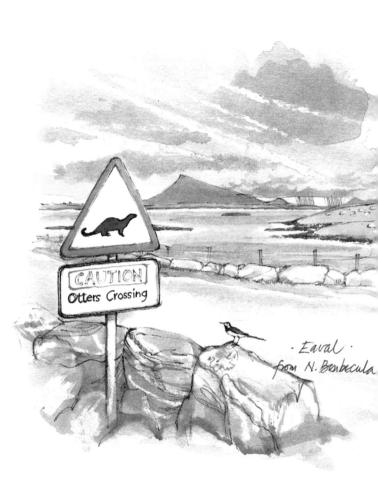

3	June			
4	June		 	
5	June			
6	June			
7	June			
8	June			
9	June			

10 June				
11 June				
12 June	 			
13 June			 	
14 June				
15 June	 ***************************************	***************************************	 	
16 June				

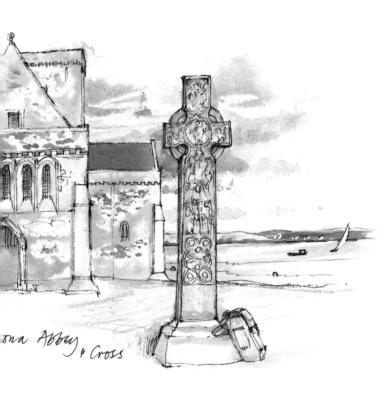

17 June

18 June

19 June

20 June

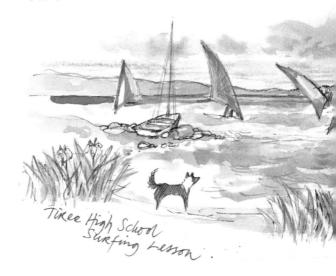

21 June

22 June

23 June

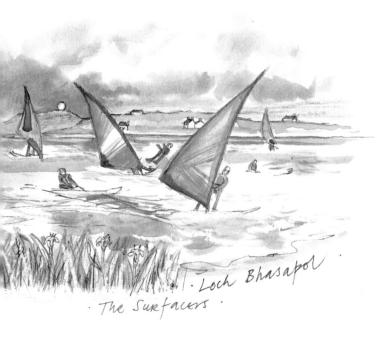

		i	

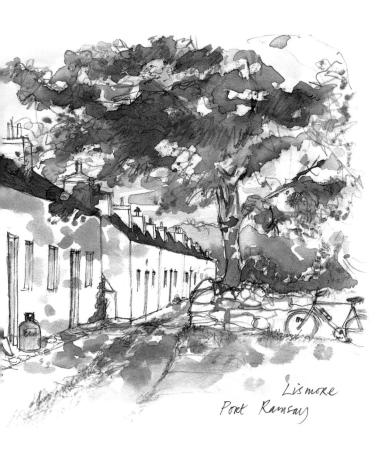

2 July

3 July

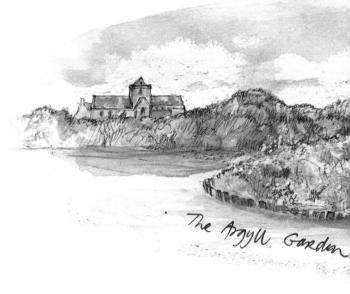

6 July

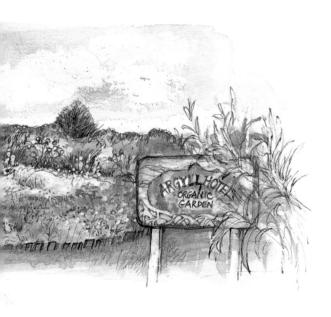

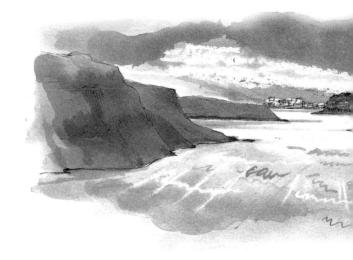

9 July

10 July

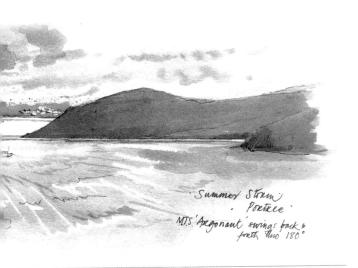

13 July

16 July

17 July

18 July

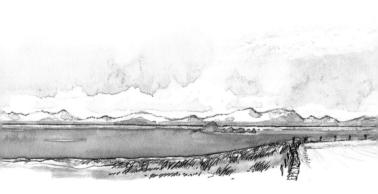

20 July

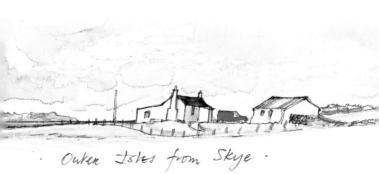

22 July				
 23 July	***************************************	***************************************	 	***************************************
24 July				
25 July				
26 July				
27 July				
28 July				

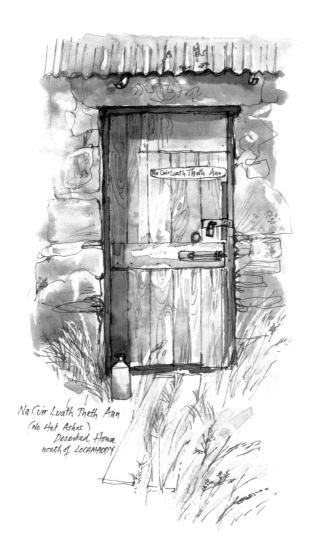

29 July		
30 July		
31 July		
1 August		
2 August		
3 August	-	
4 August		

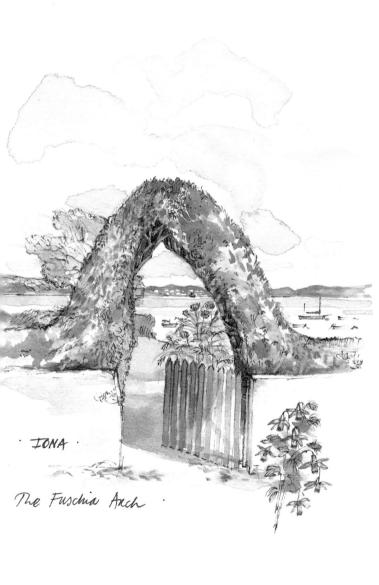

5 August

6 August

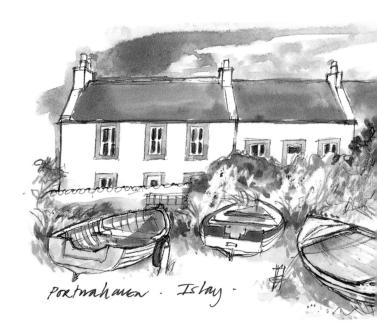

7	August				
8	August				
9	August				
10	August		***************************************		
11	August			 	

12 August

13 August

14 August

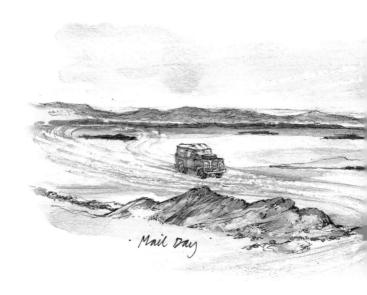

15 August

16 August

17 August

18 August

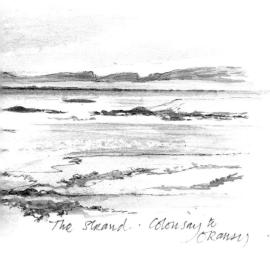

19 August			
20 August			
21 August			
22 August			
23 August			
24 August	,		
25 August			

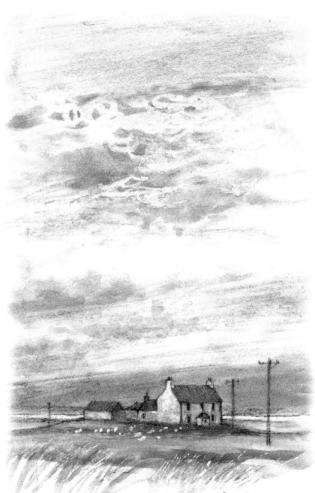

BORNISH . S. VIST. On the ROad out to RUDHA ARD VULE.

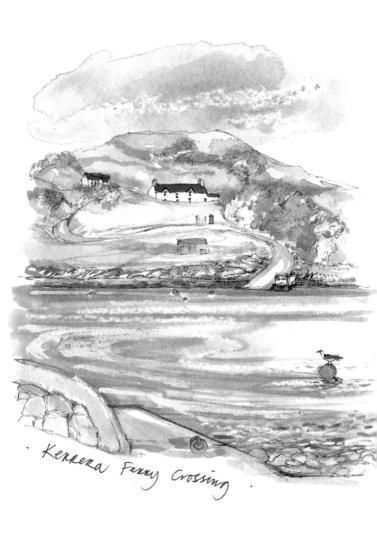

26	August
27	August
28	August
29	August
30	August
31	August
1	September

2	September
3	September
4	September
5	September
6	September
7	September
8	September

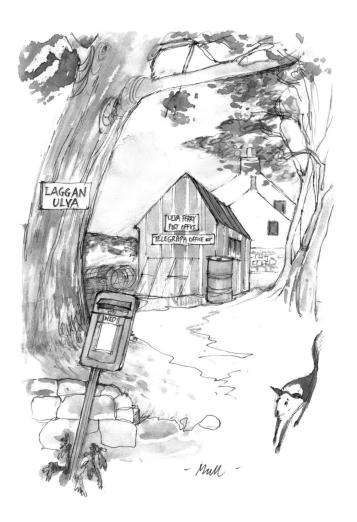

9	September		
10) September	 	
11	September		
12	2 September		
13	September		
			-
			/iccade

14 September

15 September

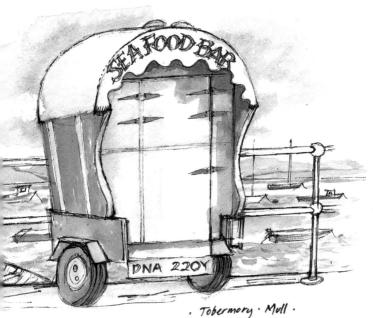

MONDAY is the best day to more house from North to South.

16 September

17 September

18 September

19 September

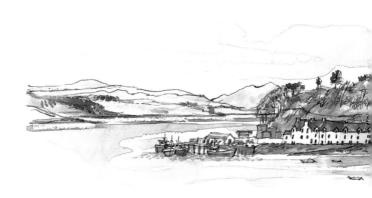

20 September

21 September

22 September

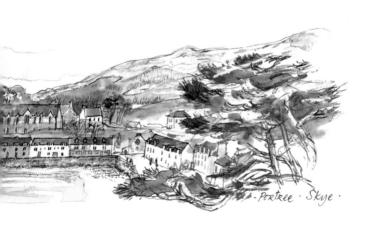

23 September	
24 September	,
25 September	
26 September	
27September	
28 September	
29 September	

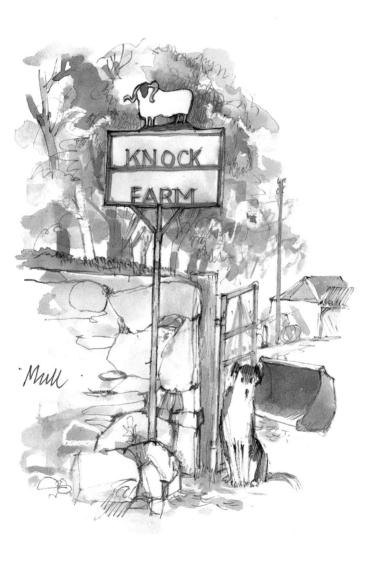

30) September
1	October
2	October
3	October
4	October
5	October
6	October

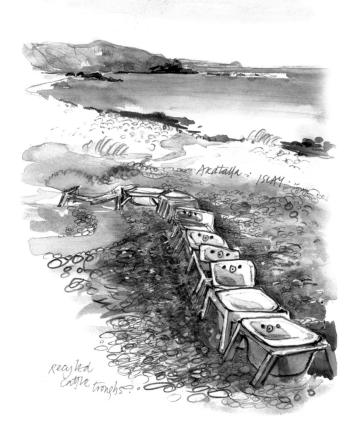

8 October

9 October

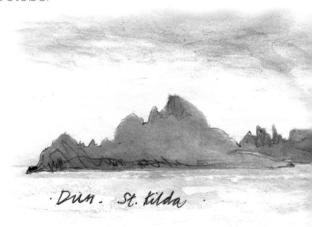

12 October

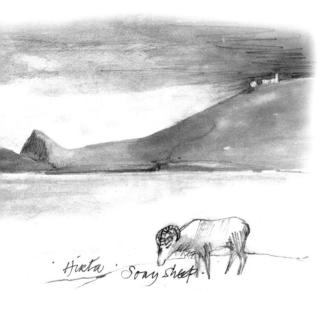

14 October			
15 October	No.	,	
16 October			
17 October	MANAGEMENT OF THE PROPERTY OF		
18 October			
19 October			
20 October			

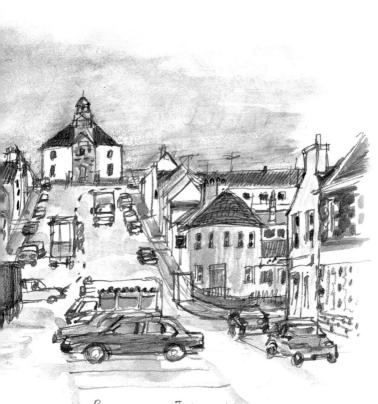

Bowmore Iste of Islay.

22 October

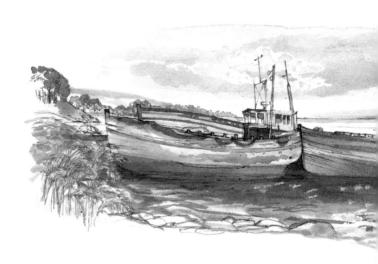

25 October

26 October

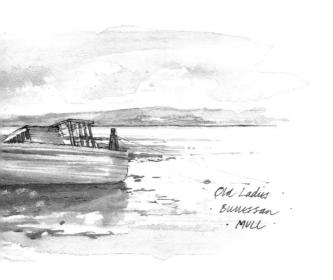

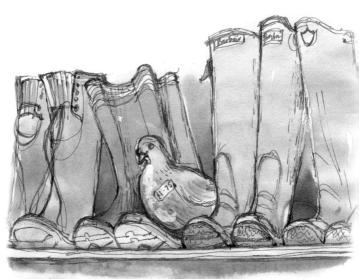

- Bridgend P.O . - Islay ~

30	October	
31	October	
do	November	
2	November	
3	November	

5 November

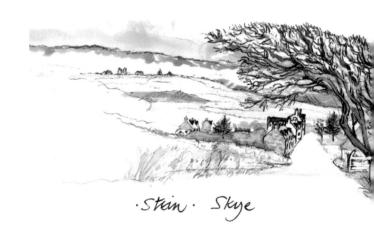

8 November

9 November

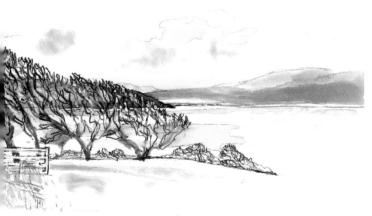

Power of the prevailing rinds ...

11 November	
	-
12 November	
13 November	
14 November	
15 November	
16 November	
17 November	

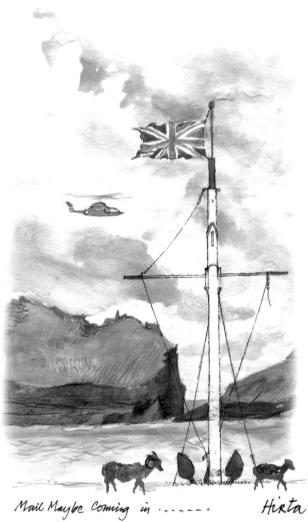

19 November

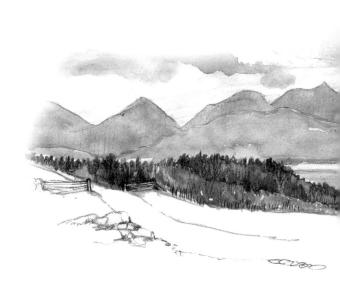

22 November

23 November

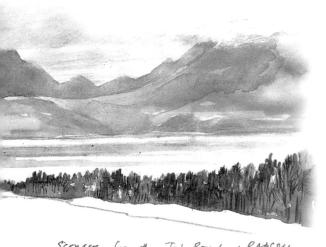

Sconser from the Top Road · RAASAY.

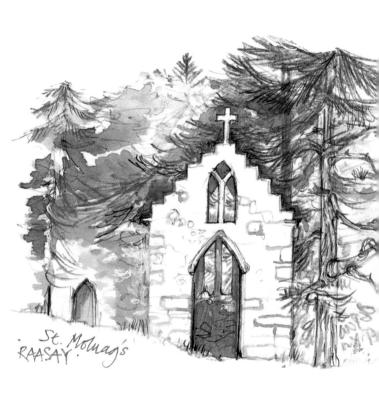

25	November
-26	November
= 27	November
28	November
-29	November
30	November
1	December

3 December

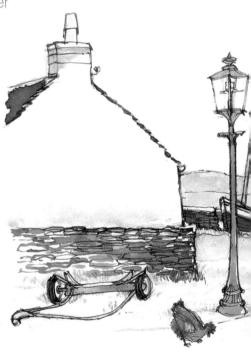

6 December

7 December

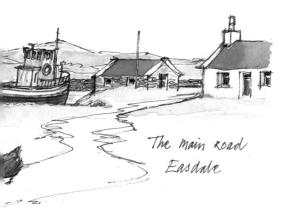

10 December

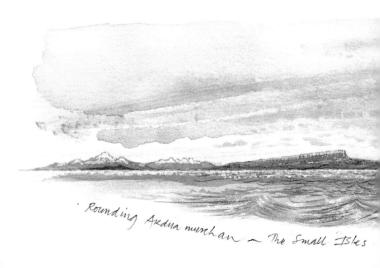

13 December

14 December

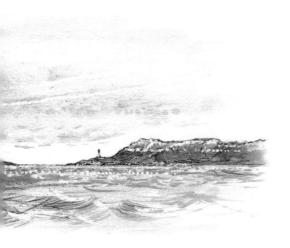

16 December	
17 December	
18 December	
10 December	
19 December	
20 December	

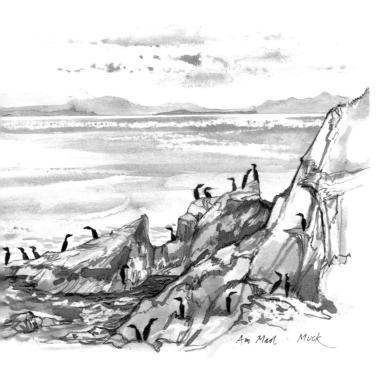

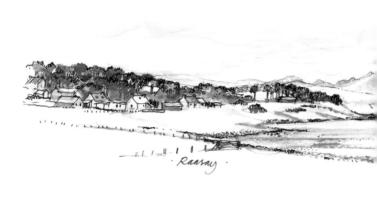

24 December

25 December

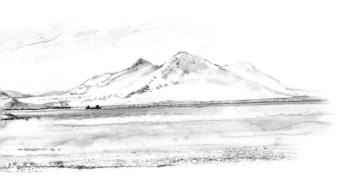

27 December

28 December

29 December

3) December	
3	December	
1	January	
2	January	
3	January	
4	January	
5	January	PRODUCE OF THE PROPERTY OF THE

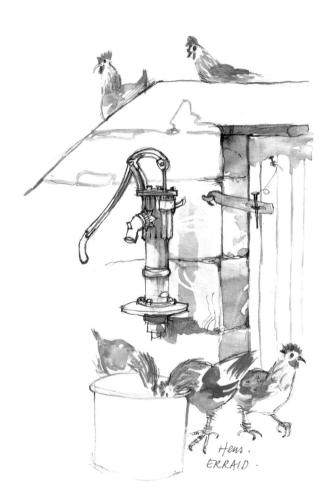

-Notes

-Notes

.